DAVID SMITH TWO INTO THREE DIMENSIONS

KAREN WILKIN

GRASSFIELD PRESS, INC.
MIAMI BEACH

First published in the United States of America in 2000

Grassfield Press, Inc.

P.O. Box 19-799

Miami Beach, FL 33139

Design by Fullerton McBride Design, Coral Gables

Printed and bound in Hong Kong

N29355

Library of Congress Catalog Card Number: 99-735351

ISBN: 1-886438-01-3

730.92 SMI

All works by David Smith © 2000 / Estate of David Smith / Licensed by VAGA, New York, NY

Essay © 1999 Karen Wilkin

Cover: *Untitled*, (detail), c. 1957, enamel on masonite

This book accompanies an exhibition curated by Karen Wilkin, organized and circulated by Pamela Auchincloss, Arts Management, New York.

Itinerary

Douglas F. Coolie Memorial Art Gallery Reed College, Portland, Oregon	April 18 - June 18, 2000
Newcomb Art Gallery Tulane University, New Orleans	December 1, 2000 - February 18, 2001
Mary and Leigh Block Art Museum Northwestern University, Evanston, Illinois	March 7 - April 26, 2001
Lyman Allyn Museum of Art At Connecticut College, New London, Connecticut	June 25 - August 26, 2001
Lowe Art Museum University of Miami, Coral Gables, Florida	September 20 - November 11, 2001
National Academy of Design Museum New York	November 27, 2001 - January 27, 2002

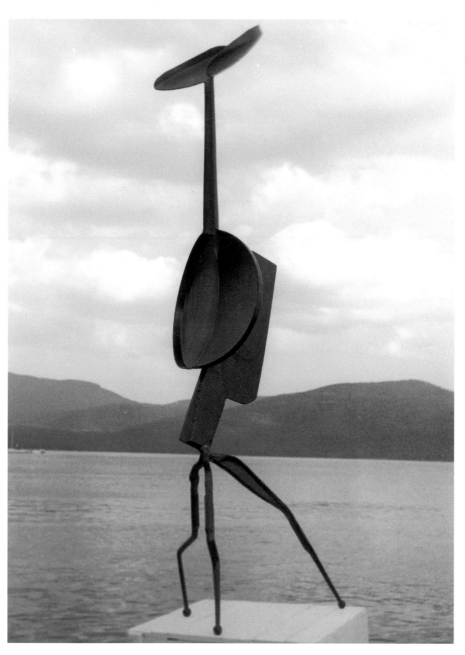

ill. 1 Tanktotem III,
1953, steel, 84 1/2" x 27" x 20",
collection of Mr. and Mrs. David Mirvish, Toronto, Canada
photograph by David Smith

DAVID SMITH TWO INTO THREE DIMENSIONS

Every year David Smith's reputation grows. Every new showing of his work makes him loom larger, yet the full range of his achievement is still not widely understood. He remains an elusive artist. Since his death in 1965, exhibitions throughout the world have helped to expand knowledge of Smith's art, but in spite of them and in spite of a steadily growing body of writing on the artist, the myth of the larger-than-life American sculptor-hero seems better known than his work.

Yet so much about Smith does seem larger than life, like the stuff of fiction: his genius, his protean energy, his gargantuan appetite for work, his ambition, his sheer physical size, even his premature death at a critical time in his career. There is, too, the brooding intensity of his sculpture, the force of its undercurrents of violence and disguised sensuality. And the image of the fields surrounding Smith's isolated home at Bolton Landing, filled with rows of his challenging, potent sculpture, is unforgettable.

That image is so powerful that an idea persists of Smith as an anguished, lonely figure working, far from colleagues and contemporaries, in self-imposed exile in the hills above Lake George. But this, too, is inaccurate. The anguish and the loneliness were undoubtedly real; they pervade Smith's writings and his friends' recollections of him, but

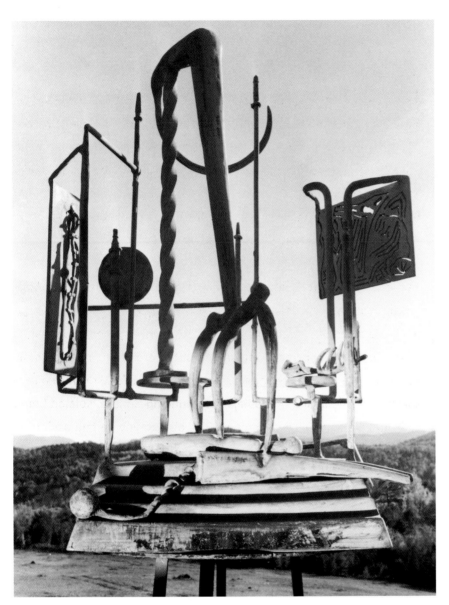

ill. 2 Cathedral,
1950, steel, with brown paint, 34 1/8" x 24 1/2" x 17 1/8",
private collection, New York, photograph by David Smith

so does an exuberant gregariousness. It is true that after 1940 Smith chose to live and work on a remote farm in upstate New York, but he was hardly isolated. He went frequently to New York, and his friends, who included some of the most gifted and radical artists of the period, as well as some of its most perceptive critics, visited Bolton Landing regularly. Smith's work clearly demonstrates his engagement with current aesthetic concerns. The spirit of improvisation, of Yankee ingenuity, that informs his best sculpture is part of its strength and its individuality, not evidence that its author was an isolated autodidact. Quite the contrary, Smith was a sophisticated, innovative artist whose work both responds to and disputes with the most adventurous ideas of his time. His art clearly embodies what we now perceive as essential aesthetic premises of daring American artists of his generation: that the source of art is the artist's interior life; that meaning is bound up with the visible history of the work's making; that the work of art at once reveals and disguises deep, intimate feelings; that ambiguity is valuable. The presence of these qualities helps to define not only Smith's work but also the postwar New York School's brand of allusive abstraction.

But if the facts of Smith's history are sometimes distorted, it is not surprising. Fundamental aspects of his life as an artist are full of contradictions. He is generally thought to have been exclusively a sculptor in steel —certainly his reputation was deservedly established by his welded sculpture—yet he saw himself as an artist who could do anything, as someone who transformed whatever he turned his hand to by the force

of his individuality. He was always ready to explore new media, new approaches, and new techniques. During the nearly four decades of his working life as a sculptor, Smith made everything from jewelry to large-scale constructions to the pylons that carried electric power to his farm-house, testing the potential of wood, stone, forged iron, cast bronze, discarded tools, machine parts, clay, and a host of more ephemeral materials; even steel appears in forms ranging from industrial scrap to specially cut sheets of pristine stainless.

The properties of materials fascinated him. Not long after he first began making welded sculpture, he made careful, highly technical notes on the characteristics of metals, recording the melting points of various ores and meticulously detailing the differences between pig iron and wrought iron. He studied steelmaking methods, comparing the open-hearth process with the electric furnace method, precisely itemizing variables of temperature, shrinkage, and the like. A few years later, he made equally exhaustive notes on the properties of copper and aluminum, as well as more exotic metals, including chromium and cadmium. One long and telling passage begins as a discussion of the characteristics of steel and ends as a rumination on abstraction and political theory.[1] Smith was equally concerned with the characteristics of painting materials. When he traveled in Europe for almost a year in 1935 and '36, he kept note-books filled with observations on technique and on the preservation of pictures.[2] Fascinated by the traces of color visible on a Cypriot grave stele, he speculated that they survived because of a chemical reaction

that bonded the hues with the supporting limestone, since the colors were "seemingly suffused with lime."[3] He managed to obtain permission to take samples of paint from sculpture at Olympia; he wanted to examine the remains of Greek polychromy under a microscope.[4]

This concern with painting issues might seem unlikely in an artist best known for working in steel, but while Smith may have earned his place in the pantheon of 20th-century art as a sculptor in welded metal, he insisted that he "belonged with painters."[5] This curious contention has often encouraged distorted perceptions of the "pictorial" nature of Smith's sculpture. A great deal has been written about the flatness of his constructions, about how much they resemble paintings, a questionable description that corresponds more to the way his subtly articulated sculptures appear in photographs—including those he took himself—than in reality. (The presumed pictorial nature of Smith's sculpture has often led, as well, to unfortunate installations of his works that suggest that they have only a single viewpoint.) But when Smith declared that he "belonged with painters," he did not mean that his sculpture was literally picturelike. Rather, it was a reminder that much of the best modern sculpture—certainly the modern sculpture that interested him the most —had been made by painters, perhaps most notably by Picasso, Matisse, and Degas.

Smith may have meant, too, that over the course of his career, he found the work of the painters who were his friends—Adolph Gottlieb, Robert

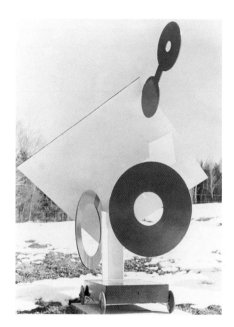

ill. 3 ***Zig VII****,*
1963, steel, painted cream, red, and blue,
94" x 106" x 85", collection of The Museum of
Modern Art, New York, photograph by David Smith

Motherwell, Helen Frankenthaler, and Kenneth Noland—more exciting and stimulating than the predictable efforts of his contemporaries among American sculptors. Direct connections certainly exist between Smith's sculptures and the paintings of his friends, an indication of fruitful exchange that seems to have been largely absent in relation to his fellow sculptors. Close parallels can be found, for example, between Smith's sculptures of the 1940s, with their symbolic emblems "displayed" on neutral supports, and Gottlieb's Pictographs of the same period, with their grids and mysterious glyphs. Similarly, in the 1960s, there are powerful likenesses between Noland's radiant Circles and Smith's polychromed improvisations on the motif, as well as between Frankenthaler's expansive stain paintings and the constructions Smith made with soft-edged, rolled-steel "crop," when he worked in Italy in 1962. These connections were deliberate. Smith even proposed collaborating with Motherwell on a sculptural version of one of the painter's celebrated Elegies to the Spanish Republic. (Motherwell declined because, he said, "I could never imagine what an Elegy would look like from the side."[6] So Smith painted his own adaptation of the motif and used it as the basis of a 1961 sculpture.)

Smith's insistence that he "belonged with painters" may be open to interpretation, but what is unequivocal is that he was a painter before he was a sculptor. "As a matter of fact," he said in a 1964 interview, "the reason I became a sculptor is that I was first a painter."[7] His formal training was as a painter; as a sculptor he was largely self-taught. Even after he

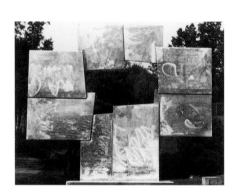

had determined that he was primarily a sculptor, Smith never abandoned painting. His enduring desire to fuse the two disciplines in colored structures that would, in his words, "beat either one," is well known. "My work of 1934-1936 was often referred to as line sculpture," Smith said in a lecture in 1952, "but to me it was as complete a statement about form and color as I could make...I do not recognize the limits where painting ends and sculpture begins."[8] Equally well known is his continuing effort to orchestrate variations of color, texture, and form in different parts of his sculptures, a "painterly" complexity achieved by a wide range of means—by changing materials to exploit their various characteristics, altering the surface of the metal, or applying paint. Smith wanted the stainless steel Cubi that preoccupied him toward the end of his life to be seen outdoors, so that the shining metal, its surface interrupted by gestural "drawing" with the grinder, would reflect the changing colors of landscape and sky. What is more significant, Smith drew and painted prodigiously throughout his working life, maintaining separate studios for different media: a factorylike sculpture atelier and a "clean" space for works on paper and canvas. Just as Matisse used sculpture to investigate spatial ideas suggested by his paintings and drawings, modeling three-dimensional forms to discover new profiles and shapes, and then translating his discoveries back into painting or drawing (and often back into sculpture again), Smith used drawing and painting to explore the implications of his sculptures, "constructing" expressive structures with bold, detached brushstrokes, unconstrained by the demands of gravity or stability that sculpture must acknowledge.

Like Matisse, Smith also reversed the process, often beginning his sculptures like paintings—as casual arrangements of parts laid flat on white rectangles painted on his studio floor—before hoisting the "picture" into an upright position for further development.[9]

Today, Smith is celebrated as one of America's great sculptors—many of us would say America's greatest sculptor. No one would deny that his most inventive, powerful, and ambitious works were in three dimensions; but it is impossible to separate his sculpture completely from his work in other media, just as it impossible to separate completely any individual sculpture from the entire trajectory of his career. The carefully numbered series names of his sculptures are misleading. Attention to Smith's scrupulously recorded dates reveals that he worked on many types of sculptures at the same time, each a development of the diverse implications of its fellows and predecessors; only later did he assign each of these disparate constructions to a coherent series.[10] (The exceptions are the Voltris, made in a single, intense, month-long campaign when Smith was invited to work in Italy in connection with the 1962 Spoleto Festival dei Due Mondi.) Similarly, Smith worked in many media simultaneously, using drawing, painting, or collage relief to refresh and recharge himself after working in steel—and vice versa. A remarkable series of uninhibited brush-and-ink landscape drawings, apparently done while Smith was fully engaged by sculpture-making during his month in Voltri, bears witness to the persistence of the practice, even when he was working under unusual circumstances. Although Smith's

paintings are rarely if ever as dazzlingly original as his sculptures—his drawings, however, are often extraordinary—his enormous body of work in two dimensions is frequently just as inventive in form, technique, and themes as his more familiar efforts in three dimensions. His works on paper and his paintings include intimate Surrealist dramas, expressive gestural abstractions, bold figure studies, and cool geometric constructions, executed in an impressive assortment of media, from etching to home-brewed egg ink to spray paint on canvas. Some are rapid, expedient notations—drawings from the model, records of current obsessions, or as Smith put it, "studies for sculpture, sometimes what sculpture is, sometimes what sculpture can never be."[11] Others, both on paper and canvas, are fully realized works of art, evidently related to the sculptures but quite independent and self-sufficient. The difference between Smith's early drawings, which depict three-dimensional constructions that could be built—typical "sculptor's drawings," in other words—and his later, completely autonomous works on paper, is dramatic.

While Smith's name will always be virtually synonymous with American sculpture in steel, his work in other disciplines is beginning to be better known. Increasingly, his sculptures are exhibited along with related paintings and drawings, so that we are at last able to see this astonishingly inventive artist whole. Yet more than thirty years and several retrospectives after Smith's death, a considerable part of his work still remains all but unknown: a large and varied group of relief sculptures.

The reliefs are testimony to both his changing concerns over the years and his recurring obsessions. They range from disturbing narratives in cast bronze to expressively worked ceramic plaques to playful assemblages of unexpected materials. Smith considered them a significant part of his oeuvre, not simply an alternative activity. The *Medals for Dishonor* (pl. 11,13), an angry, politically engaged series of fifteen bronze reliefs encapsulating passionate antiwar, antifascist sentiments, occupied him for more than three years, before he arrived at the images that he cast in bronze in 1938-39.[12] First exhibited by his New York dealer, Marian Willard, in 1940, the series was later seen at several Midwestern museums. The catalogue that accompanied the show, with texts by Smith explaining the symbolism of the Medals' harsh denunciations of corruption and hypocrisy, and an introduction by the writers Christina Stead and William Blake, confirms the importance that Smith (and Willard) attached to the series.

In 1942, after the United States had entered World War II, Smith tried to put his abilities as a sculptor of reliefs into the service of the war effort, offering "to make medallions to be awarded for extremely meritorious war production service in industry." His convictions were unaltered. He simply hoped to continue producing sculpture during these difficult years. The medallions, he wrote, could be made "without metal priority and without affecting war effort machinery" and would be "of superior artistic quality." As a final persuasive point, Smith added, with a curious mixture of proletarian solidarity and condescension: "I know workmen,

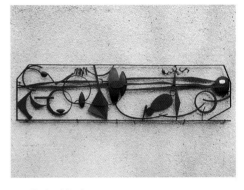

ill. 5 Pittsburgh Landscape,
September 15, 1954, painted steel, 30" x 116 1/4" x 5 1/2",
collection of Hirshhorn Museum and Sculpture Garden,
Smithsonian Institution, Gift of Joseph H. Hirshhorn, 1972

their vision, because between college years I worked on Studebaker's production line and later on ship repair in Brooklyn harbor. Therefore I know what my art must be to reach them. My conception must be simple, concrete, presenting in terms of American history, events and things they know and respect in relation to our present efforts."[13]

Smith's offer was refused; after an extended period of welding stainless steel armor plate onto locomotives in a Schenectady, New York, factory, he ended up classified 4-F because of sinus problems, but he did eventually get to design medals for other causes. A proposal for a Chinese medallion project in the early 1940s was never carried out,[14] but in the next decade he executed a number of commissioned commemorative medals, for institutions as diverse as the National Foundation for Infantile Paralysis and the Art Institute of Chicago.

Smith returned enthusiastically to the relief format around 1956-57, during an extremely fertile period that also saw the genesis of some of his most important series of freestanding sculptures. Whether he was inspired by the Chicago commission to do a larger group of reliefs, or whether he tackled the Chicago project because he was already thinking in those terms, is open to question; but whatever the motivation, he devoted an enormous amount of energy in the mid-1950s to a series of bronze plaques, a coherent, ambitious group of works that were sufficiently esteemed to be circulated as a Museum of Modern Art touring exhibition in 1961.

Since then, with the exception of the *Medals for Dishonor*, Smith's reliefs have rarely been seen. Nor have they ever been considered in their entirety as a coherent part of his oeuvre. Yet Smith made reliefs, at intervals, throughout his career, producing a challenging, complex body of work that not only mines the same rich emotional vein as his sculptures but is formally and iconographically pivotal to the evolution of his work as a whole. As a group, Smith's reliefs are not only rewarding for their own merits, but they also enhance our reading of his freestanding constructions. It is not an overstatement to say that the little-studied reliefs can transform our understanding of this brilliant artist's more familiar works.

Smith's initial experiments with three-dimensional form, the early forays that helped to determine his decision to concentrate on sculpture rather than on painting, were in the medium of relief. On his arrival in New York, in 1926, Smith enrolled at the Art Students League, on the advice of his neighbor, Dorothy Dehner, a student there herself. (Dehner, who was married to Smith from 1927 to 1952, later had a considerable career as a sculptor, especially during her last years.) The Art Students League, the artists he met there, and, to an extent, simply being in New York in the mid-1920s provided Smith's initial encounters with modernist art and determined his lifelong path. He studied painting, most importantly with Jan Matulka, a Czech Cubist who had been a student of Hans Hofmann's. Matulka's teaching encouraged the use of strongly differentiated textures in order to separate shapes; and Smith's first experiments

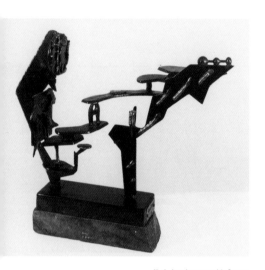

ill. 6 *Landscape with Strata,*
1946, bronze and stainless steel, 16 7/8" x 21" x 8 1/2",
collection of Dr. and Mrs. Arthur Kahn, New York

with affixing objects to his canvases, made while he was working with Matulka, were an outgrowth of this practice. These exaggerated collages became reliefs of a kind and, eventually, nearly independent three-dimensional structures. From visual differentiation of shapes by means of variations in texture, Smith arrived at literal differentiation of forms by means of changes of level and physical separation. As he described it: "The painting developed into raised levels from the canvas. Gradually, the canvas became the base and the painting was a sculpture."[15]

The process, in a sense, recapitulates the history of constructed sculpture: from Cubist painting to collage to construction with fragile materials to construction in metal. But Smith was more or less forced to find his way on his own, groping from painting to working in three dimensions. Even if he had wanted to study sculpture when he arrived in New York, he would have found no equivalent to Matulka's painting classes, no teacher of sculpture as committed to modernism or as familiar with avant-garde art. Nor would Smith have been able to see many examples of vanguard sculpture. The modernist work that was to affect him most was in its infancy—Picasso and González did not begin to make open constructions in metal until 1928—and little modernist art of any kind was exhibited in New York in the 1920s. Only a handful of galleries and a few rather shaky institutions continued the legacy of the celebrated 1913 Armory Show; the Museum of Modern Art was not established until 1929. Dehner recalled the eagerness with which she and Smith and

their artist friends visited exhibitions of modern movement art: "We looked at everything we could see. We were hungry."[16]

"Everything we could see" also included a good deal of nonmodernist art and even nonart. That Smith frequented both the Metropolitan Museum of Art and the American Museum of Natural History is confirmed not only by allusions in his work but by explicit images in his notebooks. His attention seems to have been engaged equally by Egyptian tomb furnishings, medieval household objects, antique musical instruments, weapons, Chinese bronzes, prehistoric bird skeletons, and embryology. A commission to make bases for an important collection of African sculpture offered another occasion for study.

News about radical contemporary art, which meant European art, had to be found elsewhere. The best information came from French art magazines such as *Cahiers d'art*, which Smith saw thanks to his friend, the Russian émigré painter-connoisseur-private dealer, John Graham. The much traveled, polyglot Graham knew an impressive cross section of the European avant-garde, including Picasso, González, and the Surrealists, and his annual trips to Paris provided his young artist friends in New York with information about the latest experimental art. It was Graham who, around 1930, gave Smith issues of *Cahiers d'art* with illustrations of welded metal sculpture by Picasso and González, photographs that irrevocably changed the young American's direction.

By 1932, Smith had already begun to make freestanding polychrome sculptures, combining wood, wire, stone, and coral in a manner that at once suggests Matulka's interest in textural contrasts and Smith's own continuing fascination with the amalgamation of disparate parts; in 1933, inspired by photographs in *Cahiers d'art* of Picasso and González's constructions, Smith made his first welded sculptures, almost certainly the first of their kind made in the United States.

Smith knew how to weld because of the brief stint at the Studebaker factory cited in his proposal to make medallions for the war effort. He later claimed that his aesthetic had been influenced by this experience: "In fact, my beginning before I knew about art had already been conditioned to the machine—the part of the whole, by addition..."[17] While it is debatable whether the assembly line, which added part to part, had prepared Smith for the idea of collaged, constructed sculpture—sculpture made by the accumulation of separate elements rather than by cutting away from a preexisting whole—it is clear that he found the notion of putting industrial methods and materials into the service of art deeply appealing. It was at once an act of faith, a declaration of being modern, and a way of arriving at new kinds of sculptural form. (It also impressed Smith's first audience; much of the writing about his early work dwells on his welding gear, factory methods, and workman's appearance.) Smith was sensitive to all of these aspects: "The material called iron or steel I hold in high respect," he wrote. "What it can do in arriving at a

form economically, no other material can do. The metal itself possesses little art history. What associations it possesses are those of this century: power, structure, movement, progress, suspension, brutality."[18]

Working in metal allowed Smith a new kind of formal freedom and released a new kind of ambition in him, but he never stopped exploring the possibilities of other materials and disciplines. Nor did he stop looking at and responding to an astonishing variety of sources. The notes Smith made on his year-long trip to Europe and the Soviet Union, in the 1930s, are testaments to his omnivorous appetite for everything from Northern Renaissance painting to Greek sculpture to Egyptian and Sumerian art and artifacts. They also document his obsession with images of gore and violence, as well as with the fantastic inventions of Hieronymus Bosch: describing in detail paintings of macabre martyrdoms, he carefully recorded horrifying medieval tales of brutality.[19]

The evidence of Smith's work confirms his ability to assimilate and transform these wide-ranging sources—and a great deal more. Often, particularly in his early work, it is simple to track the influence of specific works of art—and sometimes nonart—especially those that the impressionable young artist was able to study directly. It takes nothing away from Smith's individuality to say that the sculptures of his formative years—the 1930s and '40s—not only document his interest in Egyptian artifacts and medieval objects at the Metropolitan Museum but pay

explicit homage to such key works as Giacometti's ground-flung *Woman with Her Throat Cut* (1932) and his fragile "house-sculpture," *The Palace at 4 a.m.* (1932-33), or Picasso's *Guernica* (1937), and his savage antiwar cartoon-etching, *The Dream and Lie of Franco* (1937). Other early works plainly reflect the influence of Miró's paintings and of Picasso and González's pioneering constructed sculptures of the late 1920s and early 1930s; the impact of some small works by González, which Smith knew well since they belonged to Graham, is especially visible.

Smith's relationship to his various and overlapping sources is not a simple one. Anything from ancient and modern art to popular magazine photographs to the natural world could trigger his imagination and unlock his private demons, just as they could prompt him to express his lyrical side. His art is informed, often simultaneously, by the work of his contemporaries and predecessors, by vernacular objects and images, by landscape forms, and by much more. Smith expressed his admiration for some precedents and issued challenges to others. The reverberations of these varied antecedents enrich his art, although they neither define nor explain it. This enduring dialogue with a wealth of stimuli, from the art of the recent past to that of his contemporaries, from ancient artifacts to modern machine parts, parallels the lively conversation that persisted among his own works, between individual sculptures, between groups of sculptures, and between his efforts in both two and three dimensions. Since Smith himself thought of his art as a seamless whole, it is essential to follow this conversation, to consider his works in

ill.7 Lectern Sentinal,
1961, stainless steel, 101 3/4" x 33" x 20 1/2",
collection of Whitney Museum of American Art.
Purchase with funds from the Friends of the
Whitney Museum of American Art. 62.15
photograph by David Smith

all media in relation to one another rather than in isolation. In this context, his little known reliefs gain enormous importance. They constitute a coherent, independent, and continuing body of work and are intimately related to everything else that he did. Perhaps because of the pictorial nature of relief, Smith seems to have used the medium to bridge the gap between painting or drawing and sculpture, so that these works can be read as the "missing link" in his varied oeuvre.[20] Smith often composed his reliefs, for example, as he composed his paintings, spreading discrete images across the field, their relationships unconstrained by structural needs. In his early bronze reliefs, these images are often rendered with an explicitness that he usually reserved for works on paper or canvas. The closest parallels to the delicately modeled symbolic figures of the *Medals for Dishonor* are to be found not in Smith's sculptures of the period but in his drawings and prints. The chief exceptions are a group of small, expressively modeled bronzes made subsequently, in the 1940s, which treat similar themes of threat and carnage; but they are notably looser than the plaques, deriving as much of their urgency from the action of the hand on malleable material as from disquieting subject matter. The harpies and skeletons, the ravished nudes and weapons of the Medals draw upon a wide range of precedents—Renaissance medallions, British commemorative medals, Sumerian seal stones, a medical textbook, and Picasso—reconstituted and sometimes subverted as personal allusions. They are among the most unequivocal presentations of such motifs, which recur in other guises throughout Smith's work in other media. In his sculp-

tures (with the exception of the small, fierce, figurative bronzes of the 1940s) Smith usually treated these disturbing themes as undercurrents, apparently subsumed by formal issues, but in the *Medals for Dishonor* there is no ambiguity of meaning.

Dehner subscribed to the idea that abstraction appealed to Smith as a disguise, a subtle way of making use of his strongest feelings without revealing himself completely, an idea borne out by recurring images of masked figures in Smith's early work. A similar process of abstraction and concealment occurs within the general development of relief as a discipline within the larger context of Smith's evolution, paralleling the related shift of emphasis that occurs in his freestanding constructions. Smith's large expressive sculptures from about 1950 on are no less about personal myths than are his works of the 1930s and '40s, but they rely on less easily recognized imagery—so much so that they seem to be as much about the history of their construction as they are the artist's inner landscape. In the same way, a series of bronze plaques from the 1950s (and one suggestive plaque from 1939) transform the themes of the *Medals for Dishonor* into highly charged, nonspecific images that retain the skeletal character of the symbolic figures of the Medals and the shorthand detachment of their schematic settings but eliminate their narrative detail. This kind of allusive abstractness is typical of the best of Smith's freestanding sculpture at this time; the mid-1950s are the era of such ambiguous, potent works as *Running Daughter* (1956-60), *History of LeRoy Borton* (1956), and the first of the extraordinary *Sentinals* and

Tanktotems (ills. 7,1). These remarkable sculptures are confrontational structures, utterly divorced from conventional representation but no less powerfully evocative of animate presence. The best of Smith's reliefs of those years can be described in the same way.

But if the imagery and character of the bronze reliefs of the mid-1950s are characteristic of Smith's preoccupations of the period, their modest scale is not. Obviously, making reliefs, like drawing or painting, was a restful alternative to the labor of making fairly large-scale steel sculptures. (That casting reliefs in bronze also offered the possibility of multiplying the results of a single effort was undoubtedly appealing, as well.) Like painting or drawing, relief required hand gestures, rather than full body movement, and freed the artist from the need to consider how things might be supported. But making reliefs differed from working on paper or canvas in at least one very important way that may account for the amount of attention that Smith continued to award to the discipline: it was intimate yet intensely physical and tactile. Relief replaced the disembodied marks of drawing or painting with substantial, real, albeit weightless forms.

The connection between the totemic, angular configurations of Smith's abstract reliefs of the 1950s and the explicit images of his *Medals for Dishonor* clarifies readings of his essentially abstract brushstroke drawings of the same period. Even though, unlike Smith's earlier notations for potentially buildable objects, these energetic works on paper are

independent "pure" drawings, the stacked images of the reliefs confirm that the loose, staccato brushstroke images are not entirely divorced from notions of building and construction. The reliefs make explicit the relation of the ranks of floating brushstrokes of the drawings, like collapsed rows of Chinese or Japanese calligraphy, to such nonspecific, but compellingly present, sculptures as Smith's alert *Sentinels*, his hieratic *Tanktotems*, and his insistently vertical *Forgings*. Yet in the reliefs, the dissected and recombined "calligraphic" forms are disposed freely across the expanse of bronze, in the same way as the pictorial vignettes of the Medals are disposed, instead of being stacked and joined as they are, of necessity, in the freestanding sculptures.

The "intermediate" paintinglike character of relief also seems to have allowed Smith to indulge fully his desire for color in sculpture; a group of extraordinary painted mixed-media reliefs from the mid-1950s explores chromatic harmonies and variations of texture virtually unprecedented elsewhere in his work. Their soft-edged, organic forms—literally bones and shaped wood in some—have cognates in the "flying bone" imagery of the nearly contemporaneous bronze plaques, which clarifies the origins of the plaques' visual vocabulary, but the polychromed reliefs are unique in most respects. Unlike the figurative *Medals for Dishonor* or the abstract bronze plaques, the polychromed reliefs are made entirely by adding part to part, rather than by modeling or incising; they differ further from their cast-bronze equivalents by retaining the essential disparity of their parts instead of being transformed by

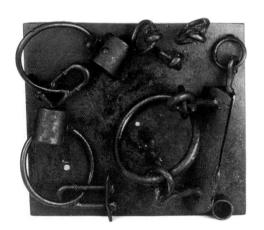

ill. 8 *Paul's Wood Bob,*
1956, steel, 10 3/4" x 12" x 4 1/2",
collection of Candida and Rebecca Smith

translation into a single, homogenous medium. The mixed-media reliefs are the result of a process of accumulation of diverse elements closely related to Smith's habitual practice as a sculptor. Yet he seems to have thought of them primarily in terms of painting, imposing color with a lack of inhibition and often a taste for abrupt contrasts of hue and surface that have few equivalents in even his most daringly polychromed sculptures. The mixed-media reliefs explore everything from elegant harmonies of dry, matte, near-monochromes to head-on collisions of shiny near-primaries; some are close-valued and subtle, while others exploit emphatic tonal contrasts. Even though the robust supporting surfaces of these reliefs may seem to reprise the canvas "bases" of the transitional constructions that Smith made when he was Matulka's student, which implies their future existence as fully freestanding objects, their brilliant polychromy subverts these implications. Smith's use of gleaming layers of automotive enamel—his preferred paint for outdoor sculptures—in many of the series further disturbs our sense of their spatial articulations, so that their bulk seems almost coincidental. The thick base panels function simply as sturdy grounds for painting events, however dramatically inflected by added materials. Shifts in color serve both to unify and to disrupt our perceptions of projecting forms and changes in level; in his freestanding sculptures, Smith used color either to enhance and clarify structure or to amalgamate complexities. (Casting in bronze, of course, was a way of unifying the diverse parts and often diverse materials with which he constructed both reliefs and freestanding sculptures.)

In addition, the equivocal nature of relief seems to have released a spirit of playfulness in Smith, who was otherwise a conspicuously intense, driven artist; witness a casual, lighthearted construction from 1956, *Paul's Wood Bob* (ill. 8), which appears at first glance to be an accidental accumulation of odds and ends in a toolbox. Even more dramatic is an undated, probably late series, made of off-the-shelf frying pans (pl. 44). Each little pan is filled with an "omelet" of plaster poured over an unlikely assortment of unnameable steel objects, the surface further animated by the contrast of matte plaster, weathered metal, and gold-tinged varnish. Irreverent parodies of such Cubist reliefs as Picasso's celebrated shelf with the piece of bread and sausage, Smith's frying pans can also be read as genial nose-thumbing at Pop Art's ubiquitous food imagery of the early 1960s—unless, of course, they predate them. Despite their vernacular associations and their throwaway air, the little frying pans are also reminiscent of one of the most surprising sculptures in the early history of modernism: Edgar Degas's reclining bather, *The Tub*, c. 1886-89. Despite obvious differences of intent and of scale, there are nonetheless striking similarities between these disparate works. Like the metal forms in Smith's frying pans, the torso and shoulders of Degas's bather are sliced and submerged by an opaque horizontal plane, contained by a dishlike surround; like *The Tub*, Smith's frying pans are at once disturbingly literal and extremely inventive. Whether Smith was consciously evoking Degas's precedent is ultimately unprovable, but the resemblances are provocative. (Like Degas, too, Smith probably intended to have his plaster and metal sculptures cast in bronze.)

ill. 9 ***Guard Rail,***
1956, iron railing with bronze plaques, 34" x 96" x 7", whereabouts unknown, photograph by David Smith

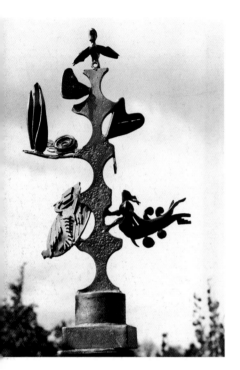

ill.10 Pillar of Sunday,
1945, steel, painted, 31" x 16 5/8" x 8 1/2",
collection of Indiana University Art Museum, Bloomington
photograph by David Smith

Often, Smith simply incorporated relief elements wholesale into free-standing sculptures, using them as signposts, punctuation, or messengers. In the 1940s, he often presented them as though on a display rack, as in *Pillar of Sunday* (1945) (ill. 10). He placed shallow relief images, like pictures hung in a miniature dwelling, on the walls of the astonishing *Home of the Welder* (1945) (ill. 11), to reinforce the generating metaphor of this evocative, wholly personal conflation of early Giacometti and the house models buried in Egyptian tombs, with an admixture of medieval reliquaries and graffiti from the Schenectady locomotive factory—among other things. In the enigmatic, elusive *Landscape with Strata* (1946) (ill. 6) Smith used applied relief medallions quite differently, positioning them to shift viewpoints and perspective. Perhaps the most apparently straightforward but provocative of these inclusions were in *Guard Rail* (1956-57, formerly Helene S. Thomson Collection, Pittsburgh; present whereabouts unknown) (ill. 9), a large work, unique in that it was commissioned by an admirer—which may explain Smith's thrifty use of existing plaques. A drawing in a workbook from the mid-1950s identifies the components as "3rd stage of Chicago," "longest bronze," "lobster," "studio," and "rose and lines," which Smith set on "stalks" just under three feet high, displaying them face up to the viewer.[21] It is tempting to equate this unusual presentation with Jackson Pollock's practice of working on the floor, approaching his picture from all sides and looking down at it, instead of confronting a canvas supported on an easel or fastened to a wall. The horizontal placement of the

plaques in *Guard Rail* recapitulates Smith's own process of working on his reliefs, presumably by placing them flat on a worktable, but it also contradicts relief's traditional association with wall-hung paintings.

Early in his career, Smith seems to have used relief to discover new aspects of images already explored as drawings or as freestanding sculptures. The wiry, linear sculpture *Interior* (1937) (ill. 12), for example, improvises inventively on an everyday studio experience, recorded in a drawing of the same year, which shows a photographer documenting one of Smith's sculptures. *Interior* is one of Smith's most ambitious and accomplished early works, signaling both his admiration for Giacometti's *The Palace at 4 a.m.* and the complete assimilation of its implications that will lead to such innovative, original "house sculptures" as *Home of the Welder*. *Interior* "collages" disparate perceptions—the photographer, his tripod and lights, his hat, a studio table, and the sculpture being photographed—to make a new, arresting object not immediately recognizable as having any anecdotal content. Yet in a relief of 1945, *The Studio* (pl. 14), Smith once again made explicit the specific image that had originally triggered his interest and—according to his workbook at least—thought enough of the result to include it in *Guard Rail*.

The relationship between Smith's later reliefs and his work in other media is extremely subtle. His abstract bronze reliefs and richly worked

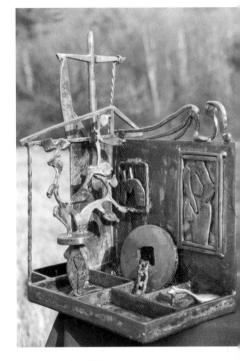

ill. 11 Home of the Welder,
1945, steel, 21" x 17 3/8" x 14",
collection of Candida and Rebecca Smith
photograph by David Smith

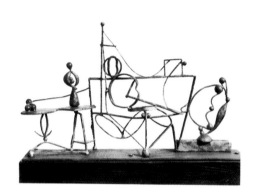

ceramic plaques of the 1950s seem to be wholly autonomous meditations on qualities of surface articulation and peripheral shaping particular to their discipline, yet they prove to be closely linked to his paintings and drawings of the same period. The rich surfaces of the reliefs could be described as solidifying the linear flourishes of Smith's canvases and works on paper—or conversely, the paintings and drawings could be said to turn the dense, inflected surfaces of the reliefs into disembodied, fluctuating expanses. The aggressive physicality of the reliefs, in turn, suggests that Smith's implacable, frontal, allover canvases of the 1950s are less closely related to Pollock's example (which the sculptor obviously knew thoroughly) than to Smith's own sculptural obsessions. The scrawled surfaces of the near-monochrome paintings seem tactile, rather than optical, so that each canvas stamps itself out as a confrontational object, rather like a vertical sculpture with a crusted, elaborated surface. This dialogue between two and three dimensions is continued by a group of richly textured "heads," made between 1955 and 1957, rather like dense, complex reliefs on vertical supports, at once reminiscent of liturgical objects and industrial artifacts.

Smith's well-documented method of starting sculptures by arranging elements against a white-painted rectangle on the studio floor is itself a kind of relief-making, transformed and fully expanded into three dimensions. The reverse side of the coin is to be found in his spray paintings and drawings of the late 1950s and early '60s, pictures that imply the absence of relief, since they are made by layering elements against a

ground, spraying over the configuration and then removing this transitory construction to reveal a kind of negative image, like the ghost of a vanished relief construction.

More important, issues inherent to relief inform all of Smith's sculptures. Admittedly they are closely related to painting issues, reminding us of the sculptor's assertion that he "belonged with painters," but they are expressed in tactile, physical ways that have little to do with painting. Much of the character of Smith's sculpture is intimately related to touch, to how elements join, to what projects—however slightly—and what retreats. These are issues of three-dimensional articulation in space, which is to say that they are sculptural, rather than pictorial concerns. This is not to deny that Smith's conception of three-dimensional articulation in space was radically different from traditional sculptural precedents. Only Picasso and González's constructions prefigure Smith's. Like these seminal works, Smith's are made by adding discrete elements to one another, not by modeling or by chipping away at a preexisting mass; they surround space or peel away from any suggestion of a central core, rather than displacing space, as the traditional monolith does. To an even greater degree than Picasso's or González's constructed sculptures, however, Smith's works occupy the same space that we do; the pedestal is either eliminated or incorporated into the sculpture itself. By perching on wheels, like wagons or pull toys, or by balancing on slender legs, like human beings or furniture, some of Smith's most compelling and original pieces straddle the boundary between what Arthur

Danto has called "mere real things" and invented, expressive works of art. Smith was obviously deeply indebted to his chosen ancestors, Picasso and González, but it should be remembered that when Smith made his first welded metal sculptures, in 1933, Picasso and González had been working in this "new tradition" for only five years. Smith was no mere disciple. He not only learned perfectly the sculptural language of open construction that Picasso and González had invented, but he expanded its vocabulary and altered its syntax. Smith's constructed sculptures are less bound by the character of existing forms than his predecessors' efforts. His *Sentinels* and *Tanktotems*, among other series, may confront us and engage our attention like individuals with forceful personalities, but they evoke the figure more by sheer verticality than by alluding to the forms and proportions of the body. It is not simply a question of degrees of abstractness—whether Smith was ever an abstract artist is questionable—but his constructions are generally more elusive than Picasso's or González's. It is all but impossible to anticipate alternative views of one of Smith's sculptures from any other viewpoint, even though planes and bars may project from one side to another. Sometimes, elements within the piece block our vision. End views are often especially surprising; the implied volume of a frontal view, for example, may dissolve when the sculpture is seen from the side, collapsing into fragile lines or thin planes seen end-on.

The distinctive character of these end views is linked with Smith's practice of making reliefs, particularly abstract reliefs and as he did in the

mid-1950s, abstract high reliefs, most notably in the series of poly-chromed, mixed-media plaques. Traditional figurative relief, which aims at the illusionism of traditional painting and relies, similarly, on the conventions and rules of perspective, demands that the work be seen from a single, frontal viewpoint in order for the illusion to be convincing. End views are meaningless, since an oblique glance would destroy illusion by revealing the peculiar flattening of the forms assumed to be further away from the viewer—forms whose position in space is unequivocal when seen head-on. Abstraction liberates the end views in relief. Abstraction makes end views potentially as significant as the "privileged" frontal view by freeing individual elements from the logical relationships that made them legible as parts of a coherent, albeit fictive deep space. Smith's most compelling freestanding sculptures could be described as four-sided reliefs. Although we can often see through sections of these constructions, and although each side is obviously related to the rest of the sculpture (and sometimes literally generated by portions of it), each side is distinct and nearly autonomous. We must rely on memory, as we do with architecture, to gauge the connections, both real and metaphorical, between what we can see from a given viewpoint and any other part of the sculpture.

Paradoxically, the question of the relationship of projecting elements to their background, an issue that might seem unique to relief, is crucial to many of Smith's freestanding works. In traditional illusionistic relief, the literal supporting plane is often treated like an enveloping sea from

which forms emerge, in order to heighten the effect of recession. Elements close to the viewer project aggressively, while those further away are subsumed by an amorphous background. It is a tactile version of the way atmospheric perspective in painting blurs distant forms and turns remote mountain ranges blue. In abstract relief, the supporting plane may either engulf what is placed on top of it or act simply as a neutral support. Not surprisingly, given his rejection of traditional illusionism, Smith usually preferred to treat the background plane of his reliefs like the surface of a stretched canvas: as a continuous, at times irregularly shaped support, against which he disposed a variety of discretely modeled forms. Sometimes, as in the *Medals for Dishonor*, he inflected and warped that continuous support; at other times, as in the polychrome relief-constructions of the 1950s, he simultaneously unified and interrupted the relationship of form and background with changes in color. But as is characteristic of Smith, these conceptions have equivalents in his work in other media. The tonal and coloristic inflections of his paintings are often closely related to the surface rhythms of his reliefs, while in his freestanding sculptures we can frequently glimpse a lingering memory of the painted rectangle on the studio floor on which Smith began his composition. It survives as a fictive transparent plane against and through which sculptural elements project.

That Smith's exploration of each discipline informed his efforts in others is clearly attested by such intricately twined connections. They are present among his works in all media at any time in his career. Generally,

Smith seems to have preferred not to think of any of his works in isolation. The provocative relationships that engendered them interested him more than the apparent distinctions that separated them. "The works you see are segments of my work life," he wrote. "If you prefer one work over another, it is your privilege, but it does not interest me. The work is a statement of identity, it comes from a stream, it is related to my past works, the three or four works in process and the work yet to come."[22] This is not to imply that Smith was uncritically accepting of his own efforts. Far from it. He was driven by his desire to achieve more with the next sculpture or with the work in progress than he had in his previous efforts—more intensity, more expressiveness, more formal invention, more potency. But the continuity and evolution of his art as a whole interested him as much if not more than the characteristics of individual works. The apparent contradiction of these attitudes would not have disturbed Smith. Ambiguity and paradox attracted him. "Our civilization," he wrote in 1950, "is a combination of poetry and perfidy. I love the poetry and I hate the perfidy. But both are valid, and I try to put both into my work."[23] Their uneasy coexistence is part of what gives Smith's art its enduring power.

KAREN WILKIN

1. David Smith Papers, n.d., Archives of American Art, Smithsonian Institution, Washington, D.C., roll ND Smith 3, Notebook #5 c. 1938, frames 482-508, and Notebook #7 c. 1939, frames 524-528.

2. Smith Papers, Roll ND Smith 3, frames 480-81.

3. Ibid., frame 477.

4. Dorothy Dehner, in conversation with the author, spring 1978.

5. David Smith, interview by David Sylvester, June 16, 1961, published in *Living Arts*, April 1964; in Cleve Gray, ed., *David Smith by David Smith*, New York: Holt, Rinehart and Winston, 1968, p. 106.

6. E. A. Carmean, Jr., *David Smith*, exhibition catalogue. Washington, D.C.: National Gallery of Art, 1982, pp. 60-61.

7. David Smith, "The Secret Letter," interview by Thomas B. Hess, June 1964, in *David Smith*, exhibition catalogue. New York: Marlborough-Gerson Gallery, 1964; in Garnett McCoy, ed., *David Smith*, New York: Praeger Publishers, 1973, p. 182.

8. David Smith, "The New Sculpture," read at a symposium on "The New Sculpture," Museum of Modern Art, February 21, 1952; in McCoy, p. 82. Among the earliest of Smith's polychrome sculptures, *Billiard Player Construction* (1937, Dr. and Mrs. Arthur E. Kahn) not only has planes differentiated by contrasting red and blue paint but also has a surprising painted passage on the back, which completes or continues forms partially rendered in three dimensions. The complex polychromy of *Helmholtzian Landscape* (1946, Mr. and Mrs. David Lloyd Kreeger) reflects Smith's interest at the time in formal color theory such as that of Helmholtz and Chabrol. Numerous later works explore a wide range of painting methods, from differentiating planes with contrasting colors to brushy allover applications of superimposed hues. For a detailed discussion of Smith's techniques for coloring his sculptures see Albert Marshall, "A Study of the Surfaces of David Smith's Sculpture," in *Conservation Research* 1995, Washington, D.C.: National Gallery of Art,1995, pp. 87-109.

9. For a detailed discussion of Smith's working methods, see Carmean, 1982, and Stanley E. Marcus, *David Smith: The Sculptor and His Work*, Ithaca and London: Cornell University Press, 1983. For a discussion of Smith's working methods in making bronze reliefs, see Jeremy Lewison et al., *David Smith, Medals for Dishonor 1937-40*, exhibition catalogue. Leeds: Henry Moore Centre for the Study of Sculpture, 1991.

10. The numbering and sequences of Smith's series are often irregular. The dates of making (or of completion) recorded on the works do not always correspond with the sequence of title numbers. See Carmean for detailed discussion.

11. Smith Papers Roll ND Smith c. 1952 Reel 4, frame 360. Reprinted Gray, p. 104.

12. Gray, p. 29. Originally from autobiographical notes made by Smith around 1950, Papers, ND Smith Reel 4, frames 264-82.

13. Smith, letter to Robert Nathan, War Production Board, May 30, 1942. Smith Papers, Roll ND Smith 1, frames 280, 281.

14. Smith Papers, Roll ND Smith 3, Notebook #11 early 1940s, frames 621-30, Notebook #17 c. 1942, frames 716-18, and Roll ND Smith 4, Notebook #41 1944-54, frames 21-22 record Smith's research and alternative proposals based on Chinese imagery.

15. David Smith, "The New Sculpture," in McCoy, p. 82.

16. Conversation with Dehner, spring 1978.

17. David Smith, "The New Sculpture," in McCoy, p. 85.

18. Ibid., p. 84.

19. Among the most outstanding records of Smith's diverse interests: Smith Papers, Roll ND Smith 3, frames 452-62, 466, 603, 611, 642-43, 701, 732, 845 and Roll ND Smith 4, frames 16, 89.

20. It is possible, for example, to interpret one of Smith's first welded sculptures, *Saw Head* (1933, Candida and Rebecca Smith) as a kind of relief "displayed" on a stick. Features are suggested by a variety of found objects placed against the flat expanse of a circular saw blade, but the resulting relieflike construction could easily have been intended as a kind of allusive realism— the face reduced to a single plane, against which features project.

21. Archives of American Art, Albert E. Kahn Papers, Roll 2300, Part II. David Smith Workbook, c. 1954, frames 127, 128. The identifications of the reliefs included in *Guard Rail* listed in Rosalind E. Krauss, *The Sculpture of David Smith, A Catalogue Raisonné*, New York and London: Garland Publishing, 1977, do not correspond with Smith's descriptions. Until the piece is located, it is impossible to resolve the question.

22. Smith Papers, Roll ND Smith 4, frame 360.

23. Quoted by Emily Genauer, "Art and the Artist," *New York Post*, April 5, 1969. Originally from "The New Sculpture."

PLATES

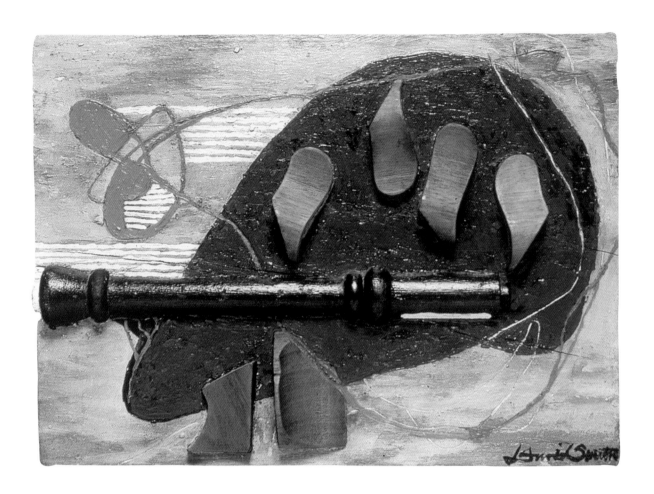

Plate 1. *Untitled (Virgin Islands Relief)*, 1932, oil on wood with wooden pieces, 18" x 22 1/2"

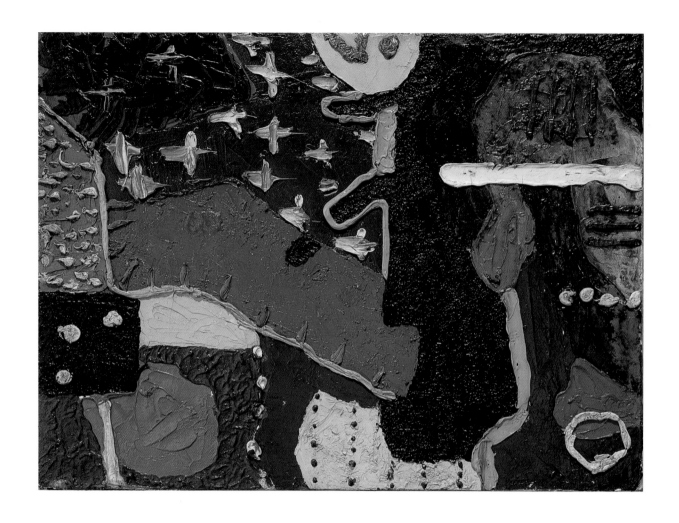

Plate 2. *Untitled*, c.1930, mixed media on canvas, 12" x 16"

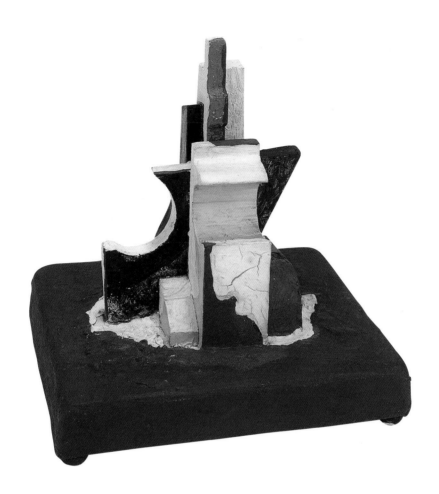

Plate 3. *Construction*, 1932, wood and plaster, painted, 9" x 6 1/2" x 5" on painted base 2" x 9 3/4" x 11"

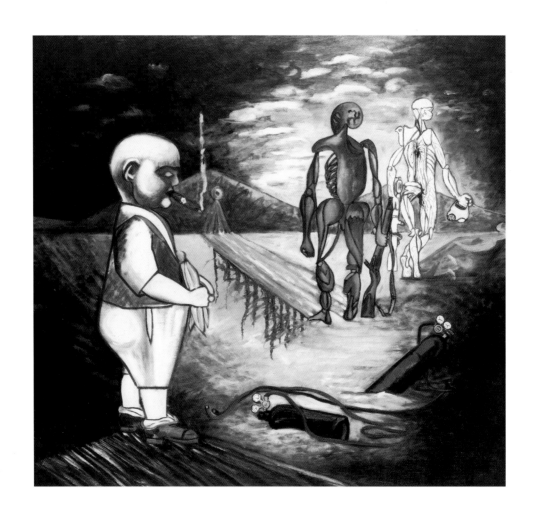

Plate 4. *Untitled*, c. 1930, oil on canvas, 32" x 34"

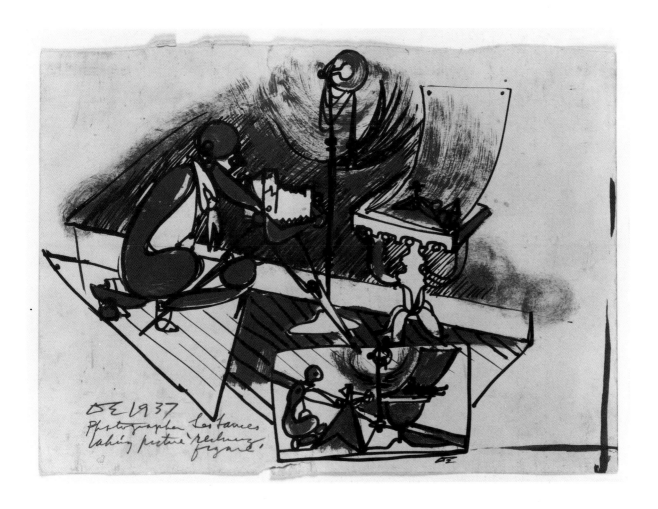

Plate 5. *The Photographer Leo Lances Photographing a Sculpture*, 1937, ink and tempera on paper, 6 3/4" x 10"

Plate 6. *Study (Death by Gas)*, c. 1938, graphite on paper, 18 3/4" x 23 3/4"

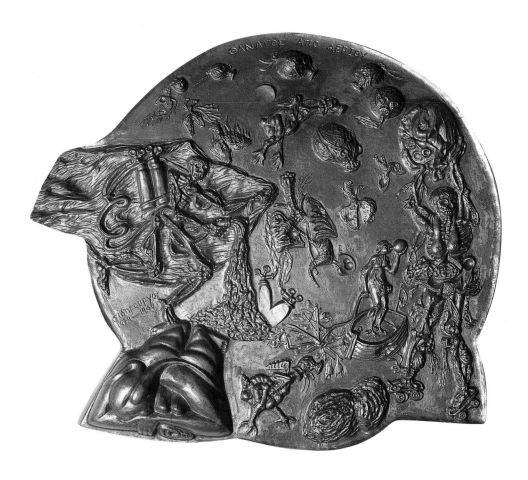

Plate 7. *Medal for Dishonor: Death by Gas*, 1939-40, bronze, 10 1/2" x 11 1/2"

Plate 8. *Study*, c. 1938, graphite, ink, and watercolor on paper, 13 3/4" x 16 7/8"

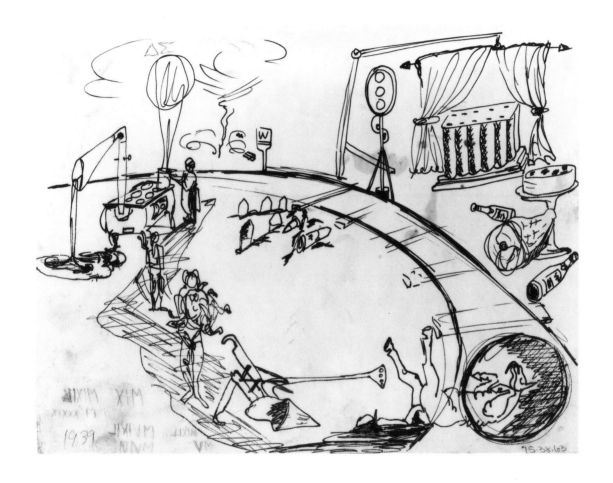

Plate 9. *Study (Food Trust)*, c. 1938, ink on paper, 9 1/4" x 11 3/4"

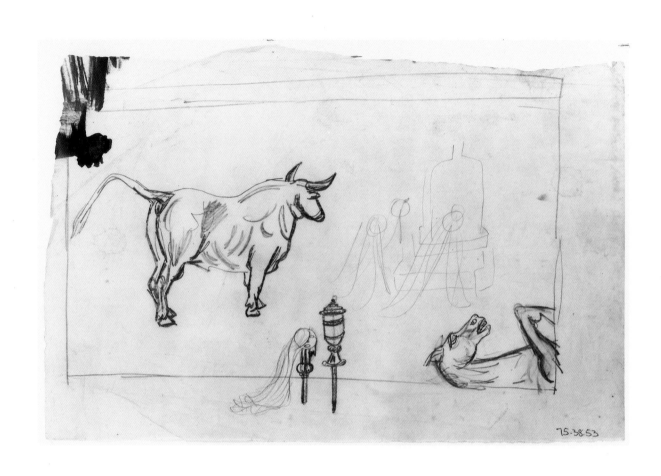

Plate 10. *Study*, c. 1938, graphite on paper, 9 1/2" x 13 3/4"

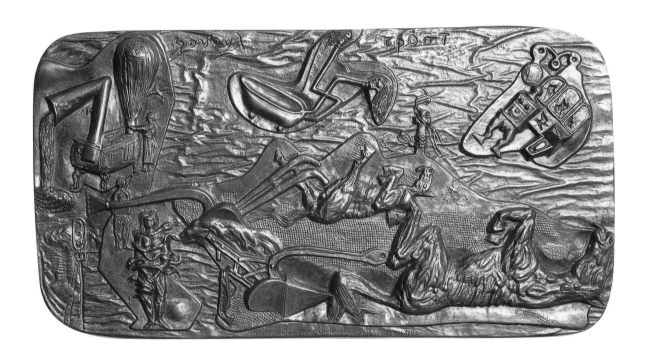

Plate 11. *Medal for Dishonor: Food Trust*, 1938, bronze, 7 1/2" x 14"

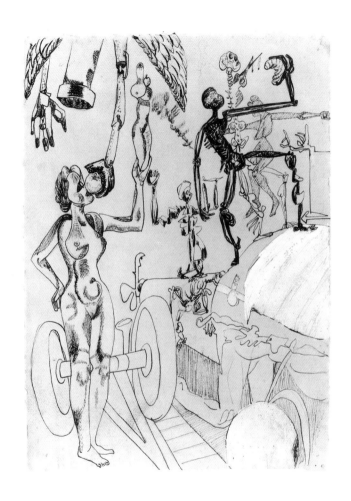

Plate 12. *Study*, c. 1938, ink and gouache on paper, 11 3/4″ x 8 3/4″

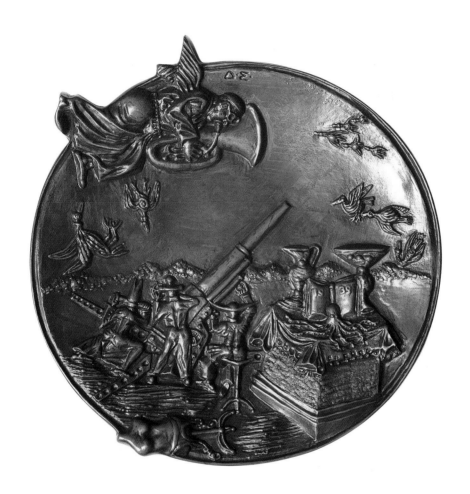

Plate 13. *Medal for Dishonor: Propaganda for War*, 1939-40, bronze, 9 3/4″ x 12″

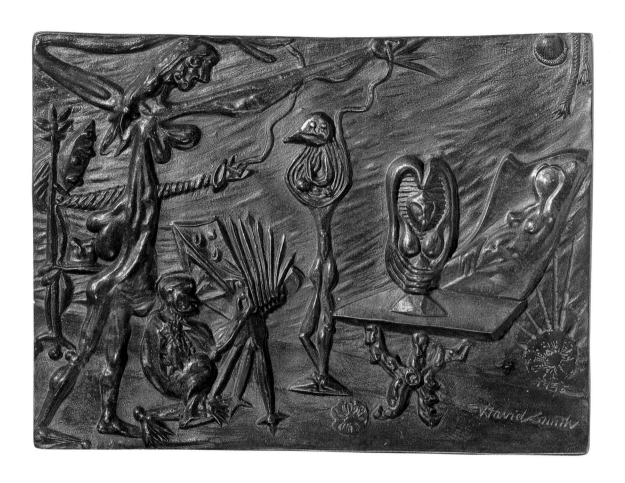

Plate 14. *The Studio*, 1945, bronze, 9 3/4" x 13" x 3/4"

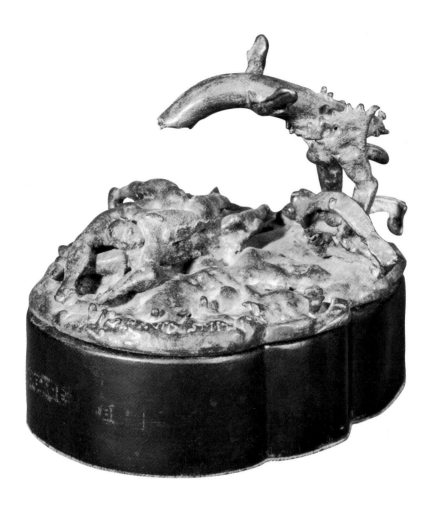

Plate 15. *War Landscape*, 1947, bronze, 9" x 7" x 6", collection of Nancy Graves Foundation, New York

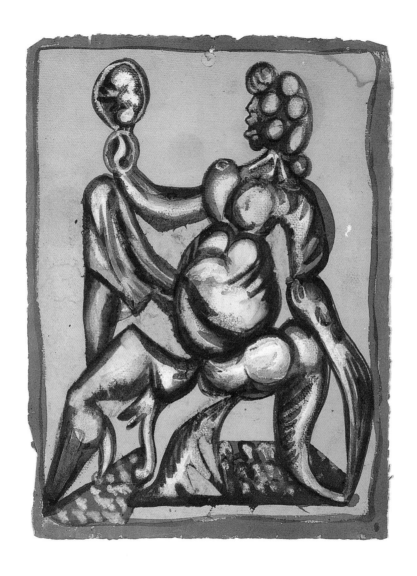

Plate 16. *Drawing for Woman in Room*, c. 1945, ink and gouache on paper, 10" x 8 1/2"

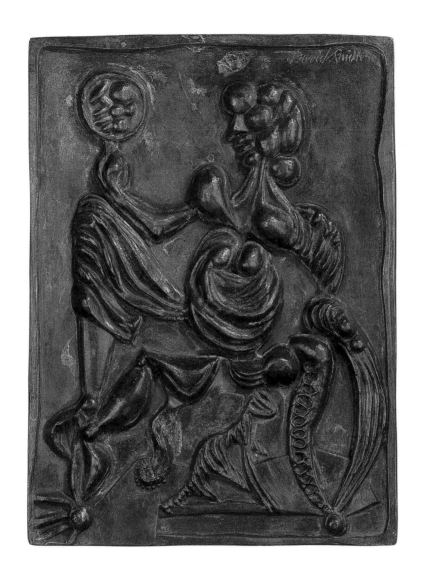

Plate 17. *Plaque: Woman in a Room*, 1945, bronze, 12 1/4″ x 9 1/4″ x 1″

Plate 18. *Variation on Woman in Room*, c. 1945,
ink and gouache on paper, 10″ x 8 1/2″

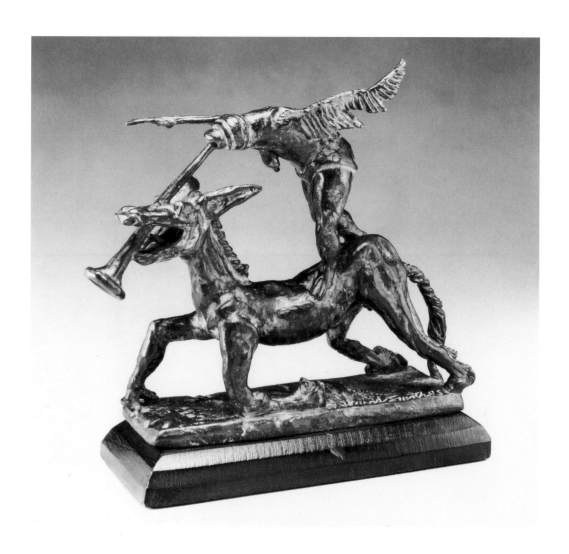

Plate 19. *Spectre Riding the Golden Ass*, 1945, bronze, 11 3/4" x 12 1/4" x 4", collection of the Detroit Institute of Arts, Detroit, MI. Gift of Robert H. Tannahill

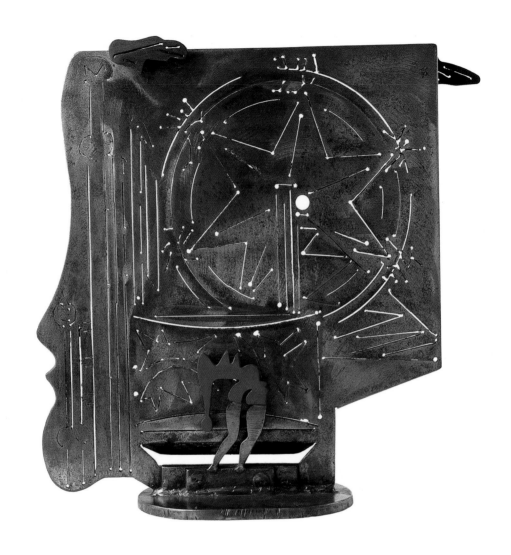

Plate 20. *Steel Drawing II*, 1945-1952, steel and oil paint, 34 1/2″ x 33 1/2″ x 11 1/8″

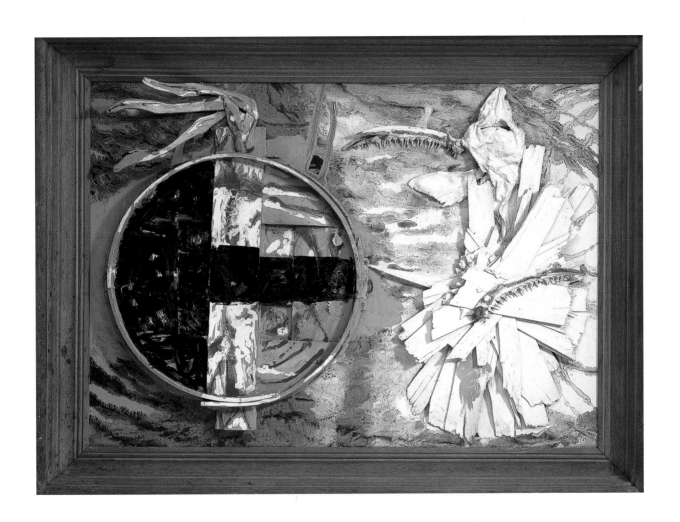

Plate 21. *Untitled (Relief Painting)*, c. 1954, mixed media, 25 3/4" x 33 1/4"

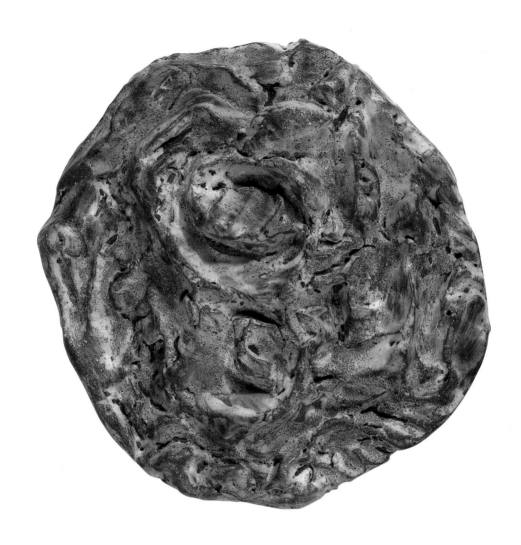

Plate 22. *IND*, 1955, clay, 8 1/2" x 8"

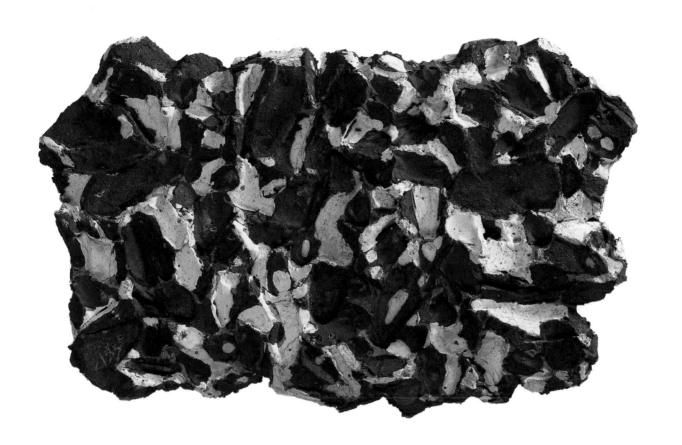

Plate 23. *Untitled*, 1955, clay, 7″ x 10 1/2″

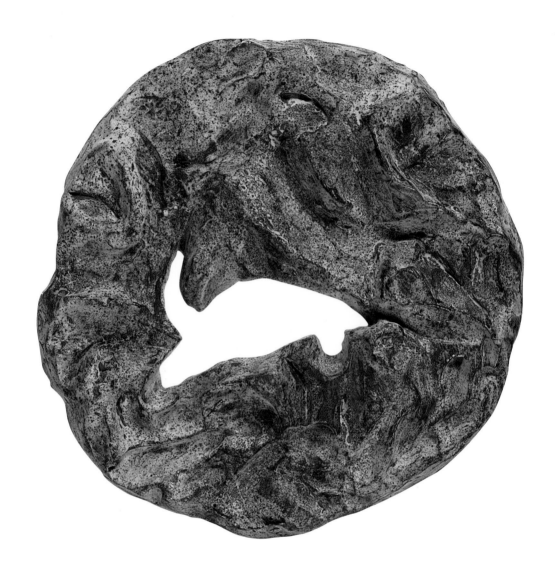

Plate 24. *Indiana*, 1955, clay, 8 1/2" diameter

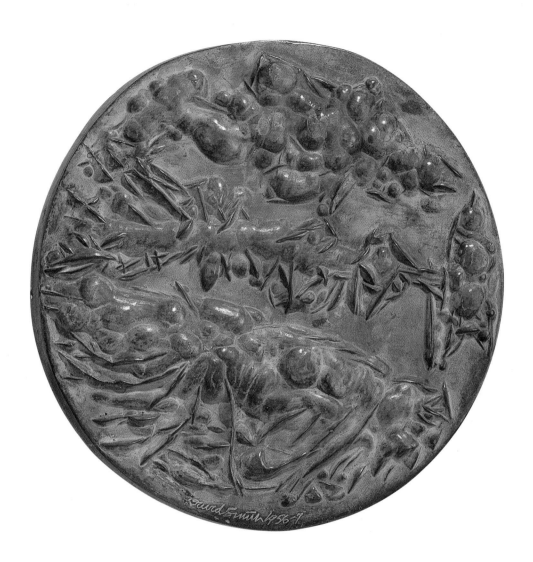

Plate 25. *Chicago II*, 1956-57, bronze with green patina, 11 1/8" diameter x 1 1/2"

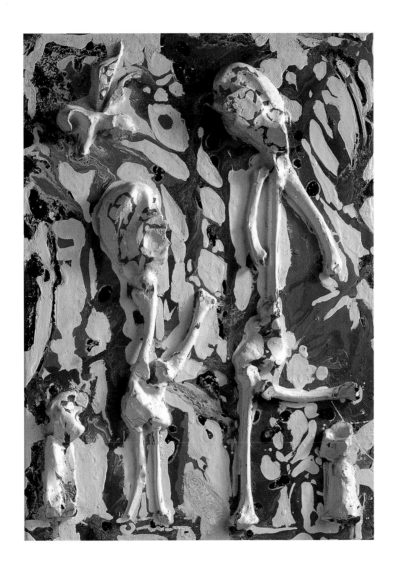

Plate 26. *Untitled (Relief Painting)*, 1956, enamel and bone, 15 1/2″ x 11 1/2″

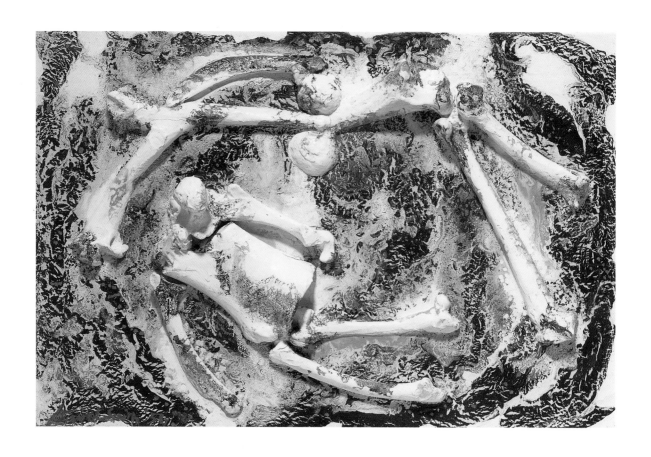

Plate 27. *Untitled (Relief Painting)*, c. 1956, enamel and bone, 11" x 15 3/4"

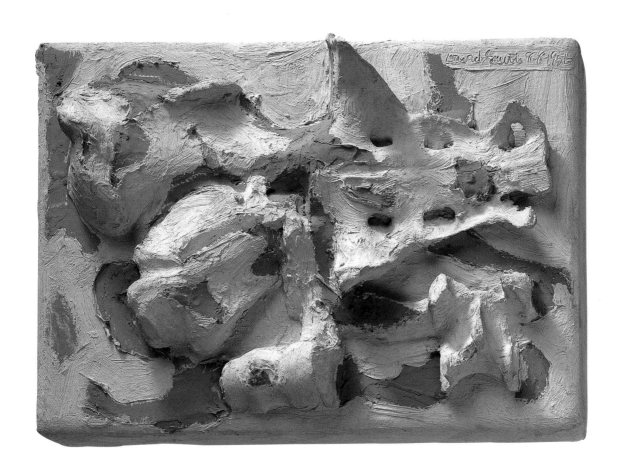

Plate 28. *Untitled (Relief Painting)*, 1956, plaster and mixed media, 11 1/2" x 15 3/4"

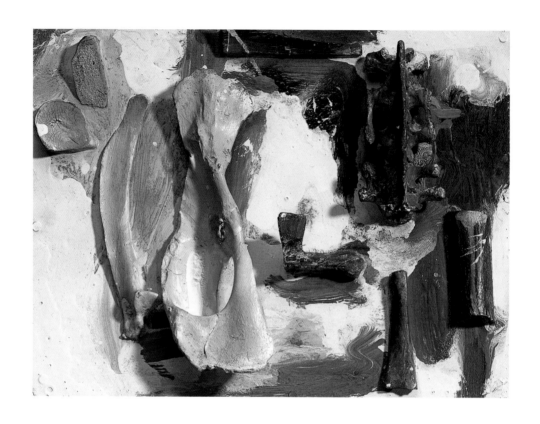

Plate 29. *Untitled (Relief Painting)*, 1958, mixed media, 7" x 9"

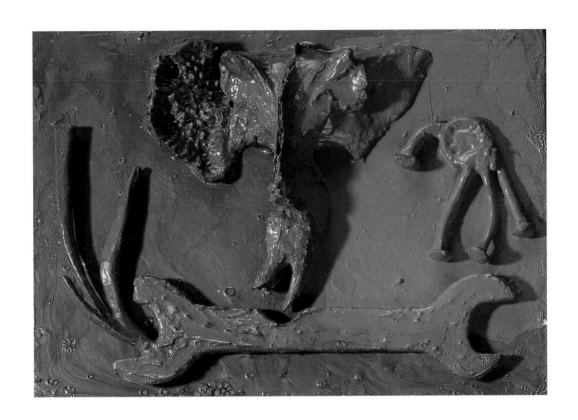

Plate 30. *Untitled (Relief Painting)*, c. 1958, automobile paint and mixed media, 9" x 12"

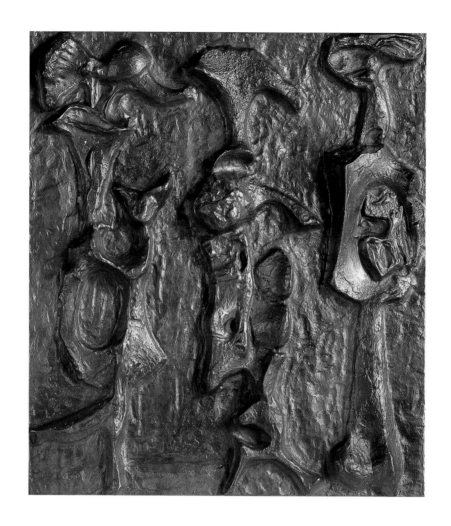

Plate 31. *Three Figures*, 1957, bronze, 19 1/2″ x 17 3/4″ x 2″

Plate 32. *Wild Plum,* 1956, bronze with silver patina, 11 1/2″ diameter x 3/4″

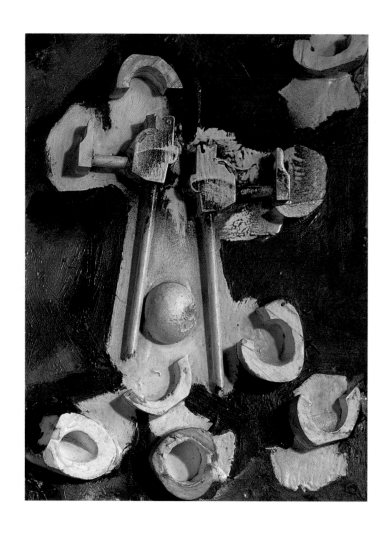

Plate 33. *Untitled (Relief Painting)*, 1958, metallic automobile spray paint, wood, and plaster, 10" x 8"

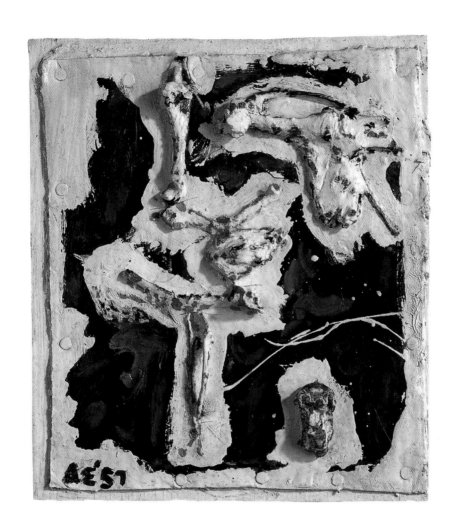

Plate 34. *Untitled (Relief Painting)*, 1957, mixed media, 10" x 9"

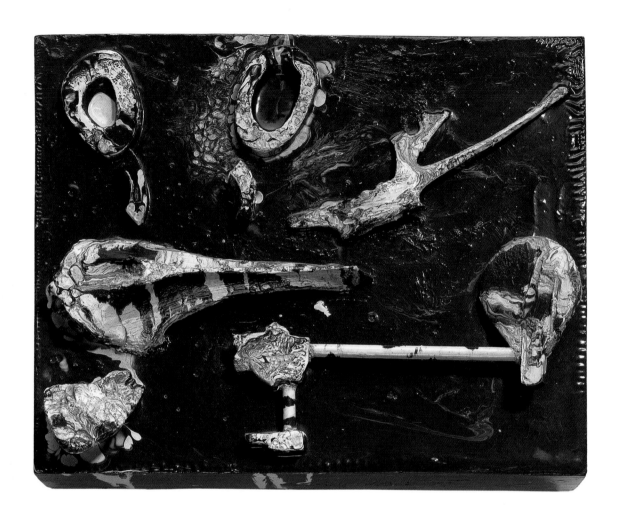

Plate 35. *Untitled (Relief Painting)*, 1958, enamel, plaster, and wood on masonite, 8" x 10"

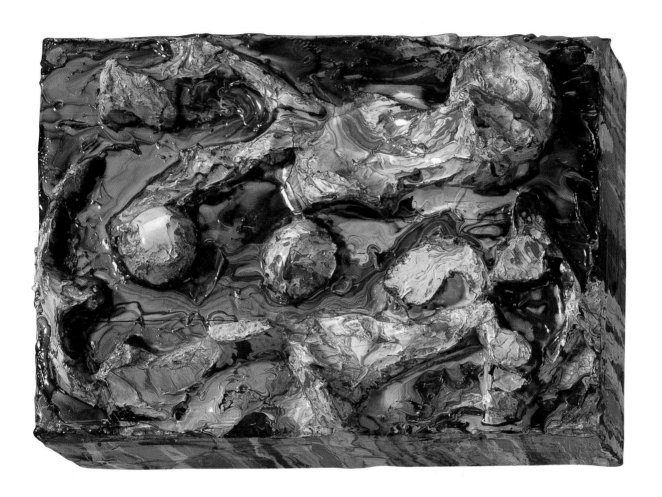

Plate 36. *Untitled (Relief Painting)*, c. 1958, enamel and bone on cigar box lid, 6″ x 8″

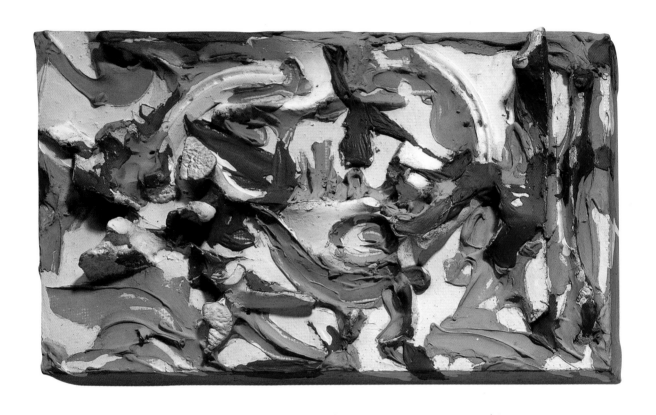

Plate 37. *Untitled (Relief Painting)*, c. 1958, enamel and bone, 7" x 12"

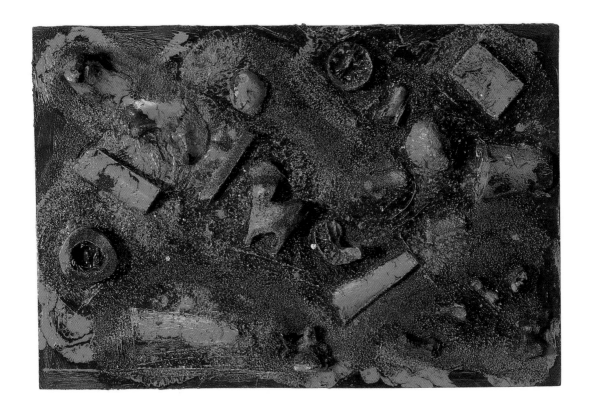

Plate 38. *Untitled (Relief Painting)*, c. 1958, mixed media, 10 3/4" x 14"

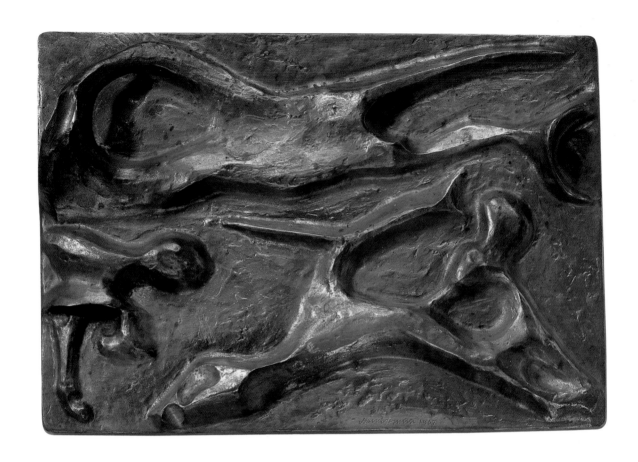

Plate 39. *Bone Up*, 1956-57, bronze, 10 3/4" x 15 1/8" x 2 1/2"

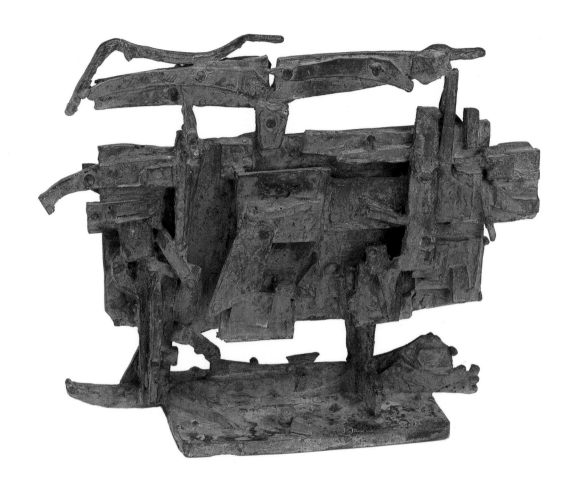

Plate 40. *Bull in Landscape*, 1957, bronze, 10 1/2″ x 13 1/2″ x 4 5/8″

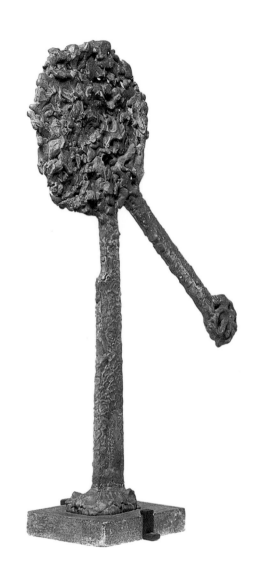

Plate 41. *Pendulum Head (Clock Head)*, 1957, bronze, 26 5/8" x 17 1/8" x 6 1/8"

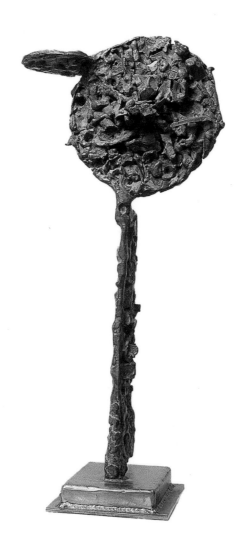

Plate 42. *Lilypad Head*, 1957, bronze, 28 1/2″ x 12″ x 8 5/8″

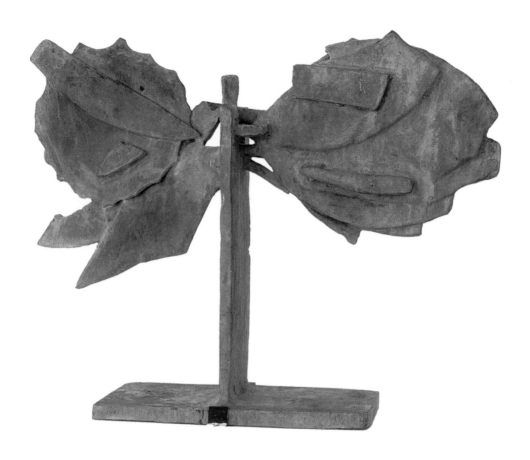

Plate 43. *Untitled*, 1962, bronze, treated with acid, 15" x 20" x 4 1/2"

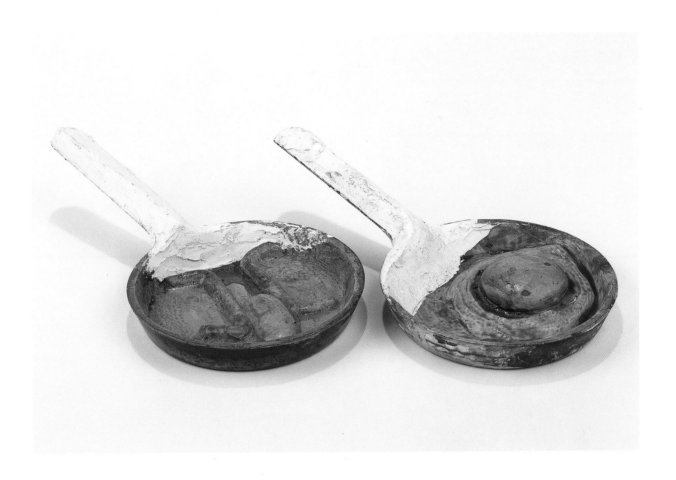

Plate 44. *Untitled*, no date, frying pans, with steel and plaster additions, each 6″ x 12″ x 2 1/2″

Plate 45. *Untitled*, 1956, oil on canvas, 17" x 18"

Plate 46. *David Smith 2/22/56*, 1956, egg ink and tempera on paper, 23 3/4" x 18"

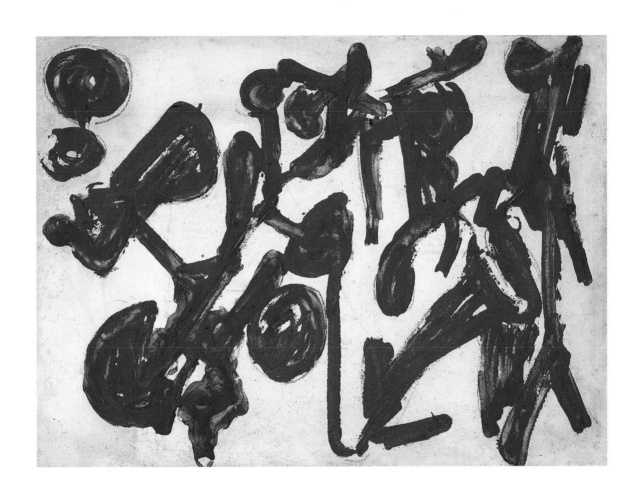

Plate 47. *Untitled*, c. 1957, enamel on masonite, 9″ x 12″

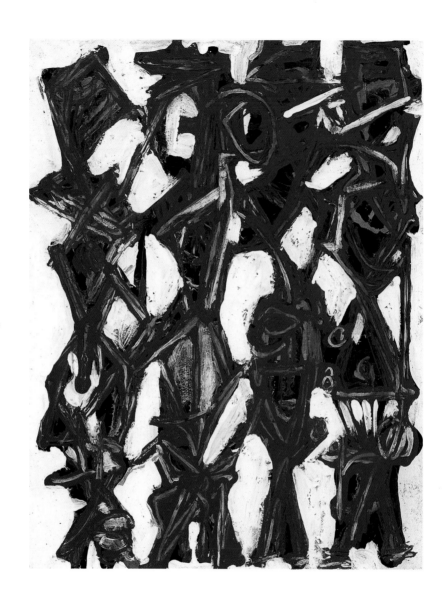

Plate 48. *Untitled*, c. 1957, enamel on masonite, 12″ x 9″

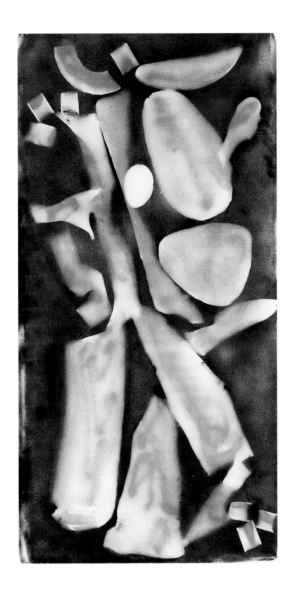

Plate 49. *White Egg with Pink*, 1958, spray paint on canvas,
98 1/4" x 51 3/4", collection of the Hirshhorn Museum and Sculpture Garden,
Washington, D.C., Museum Purchase, 1977

Plate 50. *Untitled,* c. 1959, oil and spray enamel on canvas, 72" x 17 3/4"

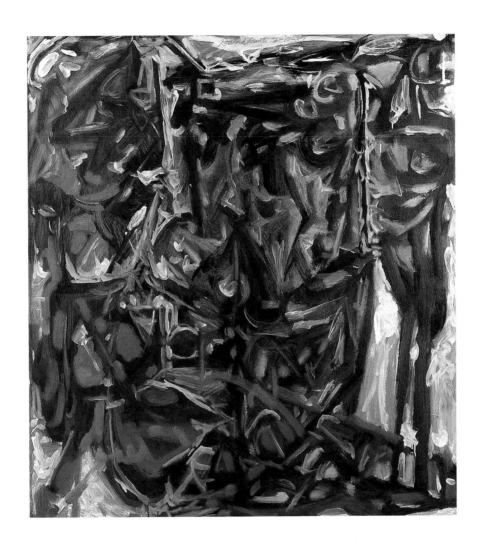

Plate 51. *Untitled*, 1957, oil on canvas, 49 3/4″ x 45 7/8″

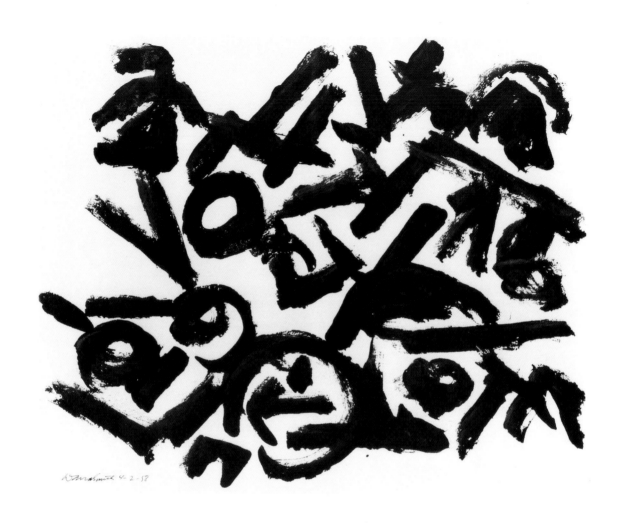

Plate 52. *David Smith 4/2/58*, 1958, egg ink on paper, 15 7/8" x 20 1/4"

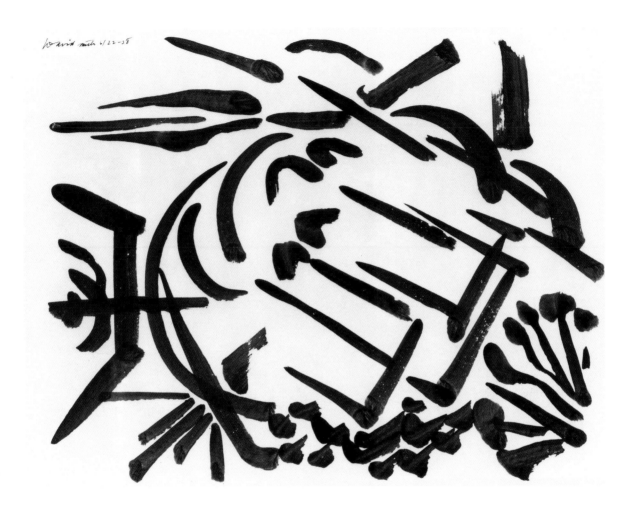

Plate 53. *David Smith 4/22/58*, 1958, egg ink on paper, 17" x 21 1/4"

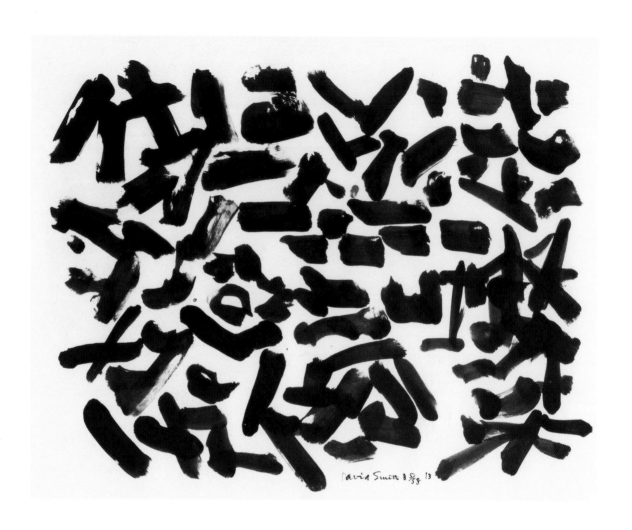

Plate 54. *David Smith B 5/58 13*, 1958, egg ink on paper, 19 3/4" x 24"

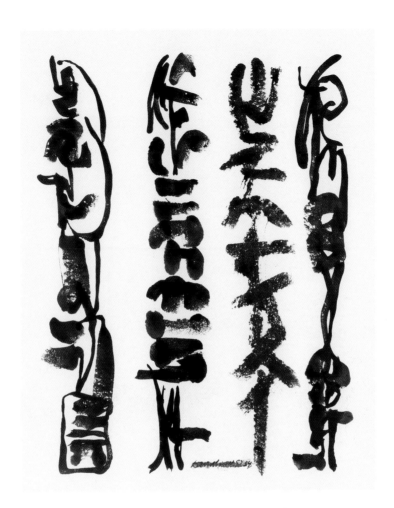

Plate 55. *David Smith 5/2/58*, 1958, egg ink on paper, 22 7/8″ x 18 1/4″

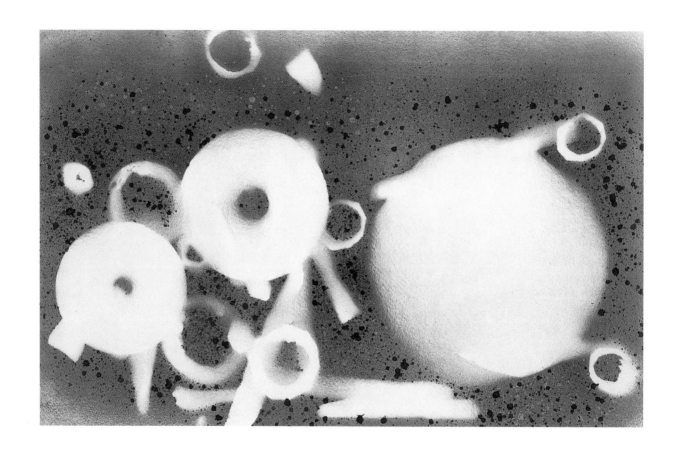

Plate 56. *Untitled,* 1962, spray enamel on paper, 13 1/2″ x 19 7/8″

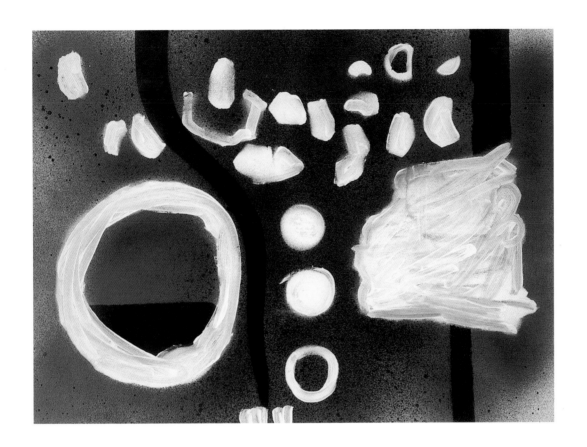

Plate 57. *Untitled*, 1962, spray enamel and oil on paper, 15 1/2″ x 20 1/4″

SELECTED CHRONOLOGY

1906	March 9—David Roland Smith born in Decatur, Indiana.
1921	Moves with his family to Paulding, Ohio.
1924	Takes art courses at Ohio University, Athens.
1925	Summer—works as welder and riveter at South Bend, Indiana, Studebaker plant. Fall—enrolls at Notre Dame University. Works for Studebaker Finance Department, which transfers him to Washington, D.C.
1926	Moves to Washington, D.C., then is transferred to New York City. Meets Dorothy Dehner and enrolls at the Art Students League, on her advice, where he will study painting and drawing until 1932, most importantly with Jan Matulka.
1927	December 24—marries Dorothy Dehner.
1928	Works as seaman on oil tanker. Moves with Dehner to Brooklyn.
1929	Buys "Old Fox Farm" in Bolton Landing, New York, where the couple will spend most summers.
1930	Meets John Graham. Sees photographs of Picasso's and González's welded metal sculpture in *Cahiers d'art*.
1931	Spends eight months with Dehner in the Virgin Islands.
1932	Makes reliefs and constructions of wood, coral, wire, and plaster.
1933	Makes carved wood sculptures; makes first all-metal sculptures.
1934	Establishes studio at a machine shop called Terminal Iron Works on Brooklyn waterfront.

1935 October—with Dehner travels to Europe; over the next year, they visit Brussels, Paris, Greece, Marseille, London, and the Soviet Union. Impressed by Renaissance bronze medals and Sumerian seal stones that he sees on this trip.

1936 Fall—returns to New York. Makes first modelled wax pieces for casting.

1937 Begins working on Medals for Dishonor (until 1940).

1938 January—first solo exhibition, including both drawings and sculptures, at Marian Willard's East River Gallery, New York. Makes lost wax bronzes.

1939 Father dies; Smith makes bronze plaque for headstone.

1940 Smith and Dehner move permanently to Bolton Landing; Smith works as machinist in Glens Falls. Willard Gallery exhibits Medals for Dishonor.

1941 Medals for Dishonor exhibited at Kalamazoo Institute of Art, Kalamazoo, Michigan and Walker Art Center, Minneapolis.

1942 Offers services to U.S. government as a designer of medallions to be awarded for service to the war effort; the offer is refused. Works nights at the American Locomotive Company, Schenectady (until 1944), assembling tanks and locomotives and welding armor plate.

1943 Commissioned by the Chinese government to design a medal for "China Defense Supplies," which is never made.

1944 Classified 4-F by the U.S. Army. Quits job in Schenectady, moves back to Bolton Landing and returns to full time sculpture making.

1945 Makes figurative cast bronze relief.

1947 Meets Robert Motherwell.

1948 Teaches at Sarah Lawrence College (until 1950).

1949 Designs three prize medals for the Art News National Amateur Painters Competition. Designs bronze medal for the National Foundation for Infantile Paralysis, New York.

1950	Awarded Guggenheim Foundation Fellowship (renewed 1951). Separates from Dorothy Dehner. Meets Kenneth Noland, Helen Frankenthaler.
1951	Included in First Sao Paulo Biennial, his first foreign group exhibition.
1952	Divorced from Dehner.
1953	April 6—marries Jean Freas.
1954	April 4—daughter Eve Athena Allen Katherine Rebecca is born. Included in XXVII Venice Biennial. Visits Europe as delegate to UNESCO's First International Congress of Plastic Arts, Venice; travels in France and Italy.
1955	August 12—daughter Candida Kore Nicolina Rawley Hellene is born. Begins making stencil drawings. Makes series of clay reliefs.
1956	Begins series of mixed media polychrome reliefs (until about 1958) and abstract bronze reliefs (until 1957).
1957	Commissioned by Art Institute of Chicago to design Mr. and Mrs. Frank C. Logan medal.
1958	Included in XXIX Venice Biennial. Begins to work in stainless steel.
1959	Included in V Sao Paulo Biennial, where he is awarded prize.
1961	Divorced from Jean Freas. The Museum of Modern Art, New York, mounts a circulating exhibition of the abstract bronze reliefs.
1962	Invited by Giovanni Carandente to participate in outdoor sculpture exhibition for the Fourth Festival of Two Worlds, Spoleto; May-July works for the exhibition in an abandoned factory in Voltri, near Genoa, producing twenty seven sculptures in thirty days.
1963	Receives Creative Arts Award from Brandeis University. About this time begins series of "frying pan" reliefs in steel and plaster.
1965	Appointed member of National Council on the Arts. May 23—dies following an automobile accident near Bennnington, Vermont.

ACKNOWLEDGMENTS

This project has had a long evolution and owes its existence to the efforts and cooperation of many people. Without the invaluable contributions of Peter Stevens, Candida Smith and Rebecca Smith, this would have been a different (and less interesting show); I am deeply indebted to them not only for their support of the project, for making works available, and for generously sharing information, but for bringing to my attention previously unexhibited and uncatalogued reliefs. I am grateful to the American Federation of Arts and particularly, to Suzanne Ramljak, for the A.F.A.'s important part in the initial development of the project and to Ann Freedman, Director of Knoedler and Company, for her role in ensuring its completion. Finally, my thanks to Pamela Auchincloss for her enthusiasm and her ability to perform small miracles.

Karen Wilkin

PHOTOGRAPHY CREDITS

Unless otherwise indicated all photography is by Günter Knop Photography, New York
Tanktotem III, Home of the Welder, Interior, Cathedral, Lectern Sentinel, Guard Rail (Terminal Iron Works, Bolton Landing), *Pillar of Sunday, Zig VII* by David Smith
Untitled (Candida) by Karen Wilkin, New York
Lilypad Head, Pendulum Head, Wild Plum by Jerry Thompson, New York
Landscape with Strata by Jim Strong, New York
Medals For Dishonor by D. James Dee
Pittsburgh Landscape by Lee Stalsworth, Washington, D.C., courtesy of The Hirshhorn Museum and Sculpture Garden, Washington D.C.
Spectre Riding the Golden Ass, Courtesy of the Detroit Institute of Arts
Steel Drawing II by Gary David Gold
War Landscape, Courtesy of the Nancy Graves Foundation, New York
White Egg with Pink, by John Tennant, Washington, D.C., courtesy of the Hirshhorn Museum and Sculpture Garden, Washington, D.C.
Lectern Sentinel, Photgraph Copyright © 1999:Whitney Museum of American Art